ARTISM™

Art By Those With Autism

Compiled by
Karen Simmons

Edited by
Bernice Pelletier

ARTISM™
Art By Those With Autism

Published by Autism Today

Home Office:
2016 Sherwood Drive Suite 3
Sherwood Park, Alberta T8A 3X3
Canada
Ph: (780) 417-2874
Fx: (780) 452-1098

USA Office:
1426 Harvard Avenue
Seattle, Washington 98124
USA
Toll-Free: 1-866-9AUTISM (1-866-928-8476)

Cover & Interior Design by

Jerry Arsenault of VeryJerry.com

Cover Collage compiled by

Chitpreet (Chipz) Bansal

Cover Collage Artists

Thank you to the artists whose images appear on our cover...

Top row (left to right):
Dane Bottino; Chelsea Welsh; unidentified at time of printing

Middle row (left to right):
Jessica Davis; Chistophe Pillault; Elizabeth D

Bottom row (left to right):
Donna Williams; Mark Rimland; Richard Wawro; Rhys Wynne

Table Of Contents

Table Of Contents

This book is dedicated to all the fine people who have an autism spectrum disorder and to all those who love them and encourage them. Without their wonderful energy, this book never would have been!

Autism Today and Autism Arts would also like to acknowledge all the agencies and individuals who support the artistic expression for people on the spectrum. **In particular, we'd like to tip our hats to....**

(M.I.N.D.) Institute

www.ucdmc.ucdavis.edu/mindinstitute

The University of California Davis Medical Investigation of Neurodevelopmental Disorders (M.I.N.D.) Institute

On April 12th, 2003, the UC Davis M.I.N.D. Institute moved into a beautiful new building on the UC Davis campus. To mark the event and to honor Autism Awareness Month in the United States, the institute assembled a significant collection of artwork created by children and adults with autism and other neurodevelopmental disorders. These pencil drawings, watercolors and oil paintings remain on permanent display throughout the institute's facilities and have been published in an exquisite book that we highly recommend. The following artists who appear in *ARTISM™: Art By Those With Autism* have additional pieces in the institute's collection.

Dane Bottino, Noah Erenberg, Phillip McMurray, Ryan McMurray, Rick Morrison, Christophe Pillault, Mark Rimland, Joshua Samuels, Andrew Stamm, Kyle Walsh, Richard Wawro, George Widener, Kristina Woodruff.

The purpose of the UC Davis M.I.N.D. Institute clinic is to provide a place where:
- experts from pediatric specialties who treat children with neurodevelopmental disorders can see patients and share ideas leading to new and more productive research,
- recruitment of subjects for research studies can be identified and evaluated; and
- practitioners can be trained in state-of-the-art methods for evaluating and treating children with neurodevelopmental disorders.

The M.I.N.D. Institute's ultimate goal is to find the cause, effective treatments and ultimately cures for a number of neurodevelopmental disorders, beginning with autism. Its staff is committed to using an integrated, comprehensive approach in treating and finding cures for autism spectrum disorders, Fragile X syndrome, and other related disorders. The institute offers new hope in unraveling the mystery that has long surrounded autism and autism spectrum disorders and answers to how families can help their children grow into healthy adults.

Creative Learning Environments

Creative Learning Environments in Austin Texas and its Executive Director, Laurence A. Becker, Ph.D. for stoking the fires of human curiosity and encouraging human beings to develop their unique talents through uninhibited self-expression!

Dedications

Sophie's Gallery

www.stmsc.org/gallery.html

Everyone at Sophie'sGallery at St. Madeleine Sophie's Centre in El Cajon, California, a gallery and studio for artists with developmental challenges. The mission of St. Madeleine Sophie's Center is to empower adults with developmental disabilities to discover, experience and realize their full potential as members of the greater community.

VeryJerry.com

www.veryjerry.com

Jerry Arsenault and his team at VeryJerry.com When *ARTISM™: Art By Those With Autism* received the Global Publishers Award in 2003, we decided to rework the format in order to do the book and its artists justice in the international marketplace.

Jerry stretched himself (and his family, we're sure!) to the limit in order to meet severely intimidating deadlines for the "upscaled" version of *ARTISM™*. As an artist and a parent, himself, he innately understood the emotional investment that so many of the artists and families have put into this project. Jerry was very generous with his guidance on all aesthetic matters and we thank him for this beautiful new edition of *ARTISM™*!

BookSurge

www.booksurge.com

We are ever so grateful to **BookSurge** and **Global Book Publishers** for recognizing the merit of this publication and giving us so much support and cooperation in nursing *ARTISM™* from concept to print.

Special thanks are due to Mitchell Davis, BookSurge's CEO who offered such an enthusiastic response when we approached him during *ARTISM's* initial planning stages.

A debt of gratitude also belongs to Stephanie Robinson, Book Publicity and Marketing Director at BookSurge. Stephanie helped us keep the project momentum going through our staff change-overs, retrieval of damaged files, and miscues on deadlines and specifications. Her patient guidance and lovely southern lilt have been heaven sent!

Our appreciation also goes to to VP of BookSurge Canada, Shannon Mobely, who presented Karen Simmons with *ARTISM's* Global Book Publishers award during the Temple Grandin / Maria Wheeler conference in Vancouver, British Columbia (www.keystotreasures.com) on January 30th, 2004. Shannon's sound advice has been most welcome.

The idea for *ARTISM™: Art By Those With Autism* was driven by the desire to celebrate the wonderful creations of individuals on the autistic continuum. Both Autism Today and Autism Arts have been witness to the incredible gifts of their online visitors with autism spectrum disorders.

Although we are two completely separate companies, we joined together for this project with the intent of providing a channel for the artists in this book to gain greater exposure for their work. We want to give everyone in the world an opportunity to appreciate these fabulous talents... not only because we understand the value of path clearers—the individuals on the continuum who paint, draw, dance, sing, play, and write their way to fulfillment and inspire their peers to do the same—but also because we believe they ought to receive compensation for their talents.

For many of these artists, "regular" full-time work will never be within reach; it is absolutely essential that they find other means to make their unique contributions to the world and support themselves. We believe that these artists represent the potential for successful self-employment for all persons with exceptionalities but especially for people with autism who interpret the world differently, oftentimes more beautifully, than the rest of us.

We have provided contact information for each artist and hope that the media, galleries, and consumers of fine art will see the long-term value in encouraging their careers.

We encourage autism-related organizations or societies to provide this book for sale at their offices or events; in return, we will direct 10% of all sales back to those organizations. For further enquiries, please contact Autism Today's office.

www.AutismToday.com

As a parent of six children, two of whom have special needs, I know how important every droplet of inspiration or ray of hope is to maintaining morale for yourself and your family. I think of the artists in this collection as ambassadors of inspiration and hope. Their creativity, their courage, and their stories touched me deeply. I published *ARTISM™: Art By Those With Autism* because I wanted to share their creativity, their courage, and their stories with the rest of the world. I know you, too, will laugh and perhaps even dab away a tear or two as you turn these pages.

I established Autism Today™ because I, myself, needed a creative, interactive, one-stop shop where I could find everything I needed to navigate the maze of ASD-related information. Now I want to put meaningful information right at your fingertips so that your decision-making process around autism-related issues is simpler, easier, and results in better conditions and clearer communications for everyone involved.

With membership in the Autism Today community, you can...
 ... View creative talent (poetry, art, short stories and humorous anecdotes) in our Online Gallery – as a matter of fact, you'll find a number of the artists from this book in our gallery

... Put questions to our expanding list of Resident Experts and view a history of their responses – as a matter of fact, Donna Williams is on our panel of Resident Experts
... Receive our monthly online newsletter with a summary of the best articles we've received over the past month and a hint of some of the issues we'll be tracking in the coming months
... Access archived articles and research summaries (over 1400 pages and growing!)

It is my sincerest hope that I can help others to deepen their understanding of and appreciation for the remarkable people on the autistic continuum who cross their paths. *ARTISM™* is one more way to advance that understanding and to celebrate the talents of individuals on the spectrum.

Contact

Karen Simmons, Founder & CEO
Autism Today
1-866-9AUTISM (1-866-928-8746)
email: Karen@AutismToday.com

www.autismarts.com

My twin sons, Phillip and Ryan McMurray, were born in 1985 and diagnosed with autism just prior to their second birthday. That was the beginning of my autism advocacy career.

In the spring of 2000, I took a trip to Glasgow Scotland to attend a congress hosted by the Scottish Society for Autism and by Autism Europe. While I was there, I had an opportunity to visit the Scottish Museum of Modern Art which was exhibiting the artwork of individuals with autism. I found the pieces to be very beautiful and intriguing.

And so Autism Arts was born! Its objective is to collect and display the largest online portfolio of international artwork by children and adults on the autistic spectrum. Like this book, the Autism Arts online project is an awareness and advocacy endeavor... The collection showcases some very accomplished pieces of artwork alongside images of innocence. Our primary concern for inclusion is not so much artistic ability as it is a willingness to explore and to express...

The puzzle pieces symbol that we use in the Autism Arts logo is a universal marker that identifies and supports individuals within the autistic spectrum. Although organizations have their own unique ways of displaying the symbolic puzzle pieces, the message is that we share a common goal to SOLVE THE PUZZLE of autism spectrum disorders once and for all!

The McMurray A.R.T.S. (Autistic Recreational Training Services) Center is a dream in the making. My goal is to acquire the financial means to buy or build a center where all disciplines of art and music therapy will be offered to individuals on the spectrum.

Donna Samuels, my friend and co-creator of Autism Arts, has offered unwavering inspiration and support for these projects. Her son Joshua's contribution to this book includes his "Mother's Day" composition, a fitting tribute to Donna's vision of hope, light, and love for our autistic population.

Through the arts, we aim to: increase the broader community's awareness and understanding of ASD; create and support opportunities in research and medical treatments; and expand the availability of educational and community based supports for individuals and families dealing with autism and its related disorders. Our virtual art gallery and our annual *Conference Connection* essay contest are Autism Arts' ways of recognizing its worldwide supporters at the same time as it educates the world at large.

Individuals affected by autism deserve the best possible opportunities to achieve a fulfilling life. We want to help our artists, authors, and musicians become as independent as possible. Our mission at Autism Arts is to offer an open window of opportunities for our children... a window that allows their light to shine through for a broader community. When those who hear "different drummers" are valued and given opportunities, we believe society will realize more wonderful possibilities than currently imagined.

Contact

Sandra McMurray, Founder & Chief Dreamer
P.O. Box 423
Eastpointe, Michigan 48021
USA
ph: (586) 777-7533
email: info@autismarts.com

ARTISM™

Art By Those With Autism

Boone Garvey

Clock1 "Age 5"

Boone Garvey was born on June 19, 1997 and lives in south Georgia. He enjoys numbers and loves to read. He has memorized several books by Dr. Seuss and can recite them spontaneously (although never when asked to do so.) He is incredibly sensitive to sound and has a very strong aversion to violence. He can name the capitols of many states and countries, in addition to telling you about currency type for most countries.

Boone has always had a fascination with clocks. He is very aware of time and can report it accurately, even without a clock, in both regular and military time. Not only does he draw hundreds of them, but also he can build a clock with ease if he's given the parts and supplies. Boone has been designing clocks with computer graphics programs since the age of three. He can't write well on paper, but he can draw almost anything he wants on his computer!

Boone's language is emerging. He doesn't really have conversations, but he's able to communicate most of his needs. Dr. Darold Treffert, the world's leading expert on Savant Syndrome, is very much interested in Boone and has featured him in an online article at www.wisconsinmedicalsociety.org/savant/boone.cfm

Clock2 "Age 5"

Contact

www.isoa.net/~nitetrax/bart.htm
email: sgarvey@isoa.net

Brad Lain

The Puzzle

Brad Lain will be 29 years old on March 15th 2004. He was diagnosed with autism at age 16.

Brad created the image *"AUTISM: A LIFELONG PUZZLE AFFECTING THE BRAIN"* in a computer paint program and affixed it as the heading to a paper he wrote about his experience of autism. He had difficulty relating to people and wanted to help them understand what autism is. His intention was to increase the tolerance and patience of those who interact with people challenged by autism and he succeeded! Many therapists, teachers, and social workers have read his work.

Brad enjoys aromatherapy, nature and the outdoors. He loves going to yard sales and thrift stores. He collects "Garfield" memorabilia, plays video games, participates in outdoor activities, and makes pine tree filled pillows for people with sensory issues.

"I spend a lot of time making filler for pillows using pine trees. The stuffing is heavy and smells good which is relaxing to me. Someday I would like to expand my business of making pillows and include others with disabilities to help me make the pillows."

Editor's note: *In January 2004, Brad lost a good deal of his artwork and his favorite familiar items to a house fire. Your words of encouragement will be a welcome comfort! His mother writes "Brad wanted to add that he loves animals. We are all thankful that his pets made it out of the fire ok. I think this came to mind for him because the house we are now living in has a wooded area and creek in the backyard and the squirrels and birds have helped take his mind off of the fire."*

Contact

http://bradlain.home.insightbb.com
email: bradlain@insightbb.com

ARTISM™

Aidan Emerson

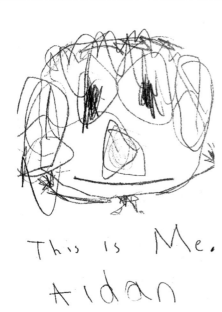

This Is Me

In 2004, Aidan Emerson turned four years old. He was diagnosed with autism at 29 months of age and is making progress through therapy and biomedical treatments. His parents are excited that he is learning so much and is happy.

He loves to draw, color, and play outside with his brother.

Contact

Sonya Emerson (mother)
1300 Daveric Drive
Pasadena, California 91101
USA
ph: (626) 351-1008
email: sonyaemerson@yahoo.com

Dane Bottino

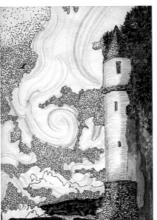

Laguna Beach

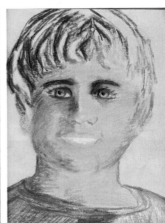

Self Portrait

Dane Bottino is a self-taught artist with autism. He lost his language skills when he was two years old, and started expressing his emotions, desires, and thoughts almost exclusively through his art. As of 2003, Dane is fifteen years old and has acquired basic functional language; however, he still prefers to communicate almost exclusively through art. He lives in Southern California.

Surprisingly, even as a three year old, he could draw with correct perspective and write using correct spelling—his grocery lists were amazing! Dane's artistic process often involves thousands of drawings on the same theme... Dr. Seuss, imaginary animals, realistic animals, cartoon characters, and more. In 2002-2003, he completed a series on the history of art—interpreting cave art, Greek, Medieval, Renaissance, Impressionism, Van Gogh, Picasso, and Warhol. He has become interested in graphic arts and aspires to create a web page to sell his art. He continues to exhibit on a regular basis; his work is included in the UC Davis M.I.N.D. Institute's collection.

Dane also has perfect pitch and sings using words; this might be an avenue for future expression. No stranger to television, Dane has been filmed by the Discovery channel and the BBC.

Contact

email: bottino2@cox.net

Carly Hatton

Carly Hatton is an 11-year-old girl who loves to share her wonderful view of the world. Her line drawings have won many amateur art contests in the province of Ontario. Carly has garnered plenty of upbeat attention from her local art community.

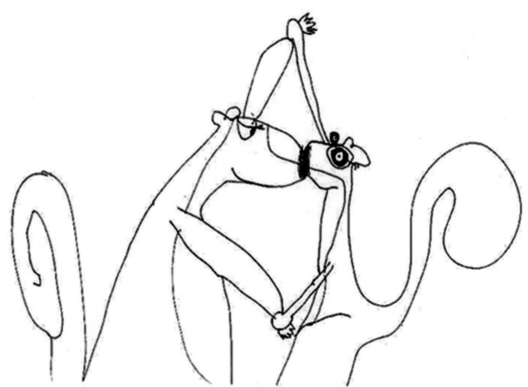

Dancing Free

Contact

www.carlysart.com
The Hattons
P.O. Box 75
Seeley's Bay, Ontario K0H 2N0
Canada
ph (613) 387-2032
e-mail: hattonr@kos.net

ARTISM™

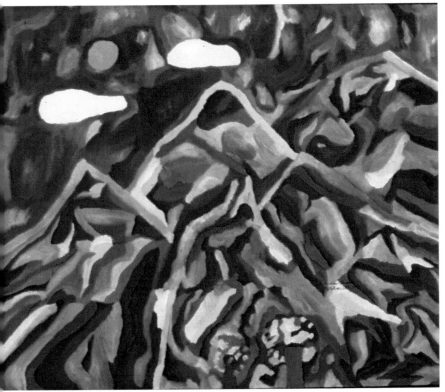

Mountains One

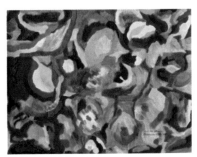

Clowns

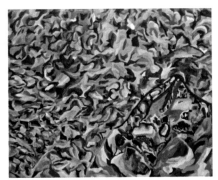

Mountains Four

Andrew Stamm is a 48-year-old self-taught artist who began painting at the age of three. His mother recognized his talent as an important medium of communication. It was through his artwork that he learned to speak at age nine.

The following list highlights selected art awards and acknowledgements:
- The Kennedy Center (Washington D.C.)
- Bumbershoot Festival (Seattle, Washington)
- One Man Show: Olympic College (Bremerton, Washington)
- "Northwest Afternoon" Television Program (Seattle, Washington)
- First Place "No Boundaries" Competition, Very Special Arts: (Five U.S. Western States)
- 2003 Painting Commission: M.I.N.D. Institute, University of California (Davis, California)

Andrew Stamm

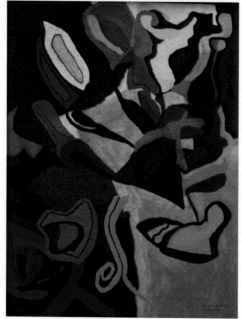

Falling Star

Andrew is surrounded by a large extended family and has filled their homes and offices with his vibrant splashes of color. His sister Leslie writes, "We are all so excited about Andy and his work being included in *ARTISM*. Andy lived at home until three years ago, a year after our mother died. With some supervision, he now successfully lives in his own home. I wish our mother, who dedicated her life to providing Andy with love and opportunities, could see the progress he has made. We're all incredibly proud of him."

Contact

Leslie Boyer (sister)
2290 NE Goldenrod Circle
Bremerton, Washington 98311
USA
ph: (360) 692-6062
email: mikelieboy@netscape.net

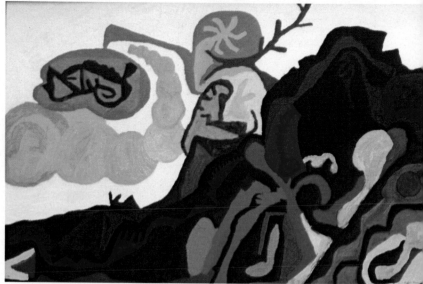

Mount St Helens

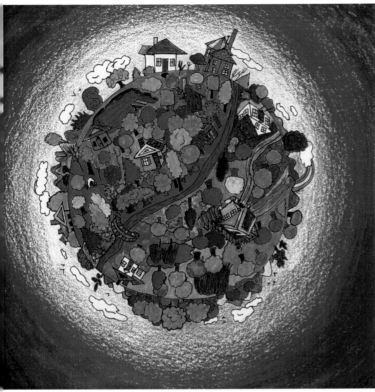

Cradlelight

Amin Collins is a 28-year-old man who was diagnosed with autism when he was two years old. Amin has always excelled in art and was in the visually talented art class at East St. John High in Reserve, LA for four years.

Amin is very versatile and can draw or paint anything from cartoon characters to portraits. Cartoons, however, are his favorites.

He has illustrated a children's book *The Cradleheads Of Cradlelight* written in collaboration with his art teacher, Janine Ward. Hopefully, it will be published someday and will help him launch a successful career as an illustrator. Amin has won several poster contests including

- Dupont's *"Honor Roll Round Up,"*
- Odyssey House's *"No Drugs For Heroes,"*
- The Humane Society's *"Adopt A Mutt."*

Judge Mary Hotard Becnel purchased several pieces of Amin's work for her courtroom in St. John Parish Courthouse.

Amin Collins

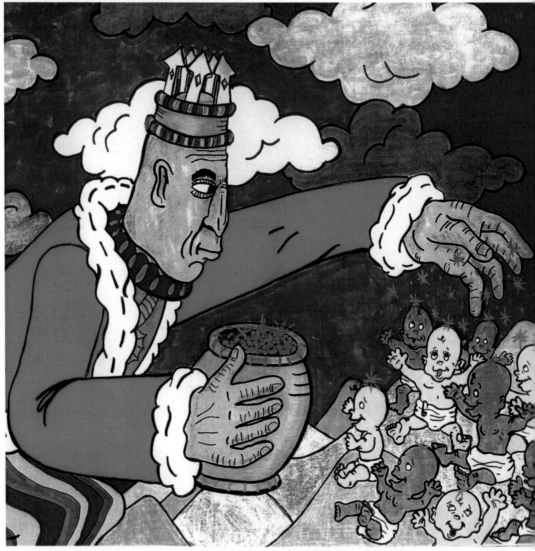

The King and The Babies

Contact

Peggy Jackson (mother)
229 Devon Road
LaPlace, Louisianna 70068
USA
ph: (985) 652-2875
fx: (985) 652-7900

ARTISM™

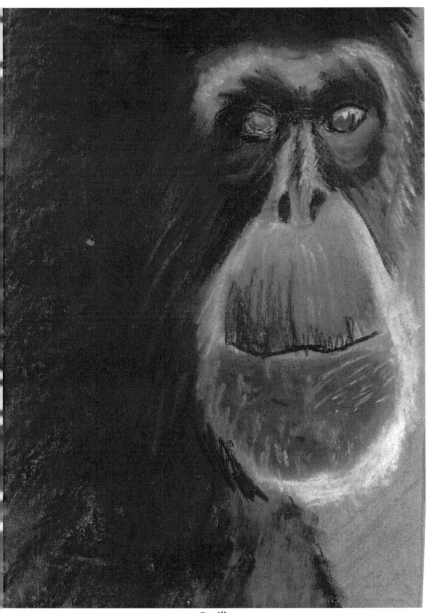

Gorilla

Andrew Young was born with autism in 1984. He lives at home with his family in Scotland. He attends Swan Street Resource Centre five days a week where he follows a structured programme that includes his favourite activity... art.

Andrew started drawing when he was eight. In the beginning, he would draw only the Looney Tune character "Taz." Through time and working with his art therapist at Swan Street, he has extended his subjects to include landscapes, people, animals, and whatever else appeals to his eye. Swan Street is run by The Scottish Society for Autism.

His work drew much positive comment during a national exhibit in June 2003. He is looking forward to his work being placed on display elsewhere and the praise that will come along with it.

Andrew Young

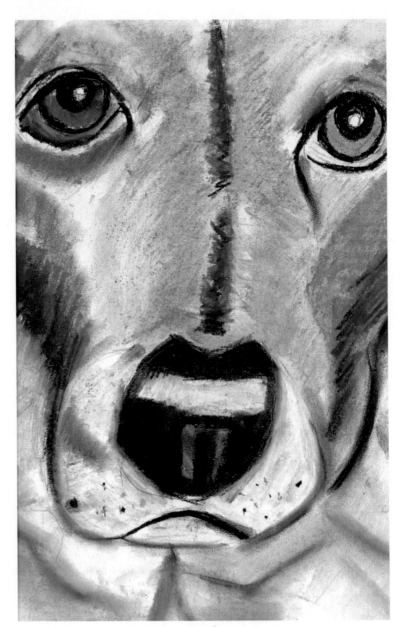

Beagle

Contact

Claire Paterson
The Scottish Society for Autism
Hilton House, Alloa Business Park, Whins Road
Alloa Clackmannanshire Scotland
UK
ph: 01 259 720044
email: paterson@autism-in-scotland.org.uk

ARTISM™ 9

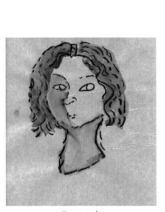

Going Shopping

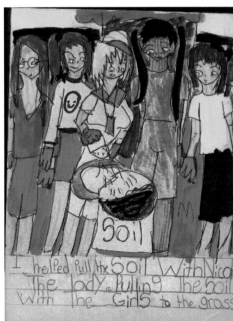

Soil Sample

Hi! My name is Chelsea Welsh. I am ten years old. I have autism.

I was born in 1993 and my birthday is October 27th. I like having my birthday in October because Halloween is my favourite time of the year. I live in Brampton, Ontario and I have lots of friends in my 5th grade class. I take piano lessons and I like bowling. My favourite food is pizza and McDonald's Happy Meals.

I love to draw pictures, including cartoon characters and fashion designs. Here are some of my pictures.

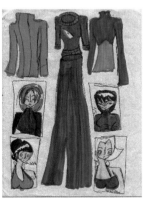

Fashion Sense

Contact

Mrs. Ann Brown
Conestoga Public School
300 Conestoga Drive
Brampton, Ontario L6Z 3M1
Canada
ph: (905) 846-2311
fx: (905) 846-3478
email: chelseawe7@epals.com

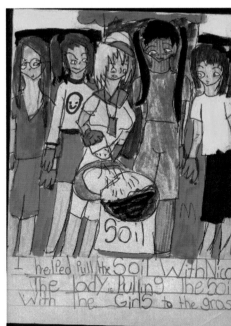

Portrait

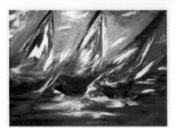

Sail Boats

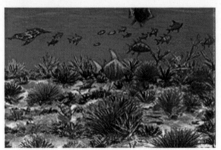

Untitled

Christophe Pillault is an autistic savant unable to talk, walk, or feed himself. He was born in Iran in 1982 and currently lives in Olivet, France.

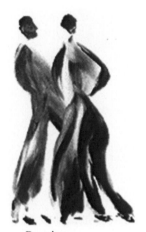

Christophe discovered painting at the age of 11. His talents were detected by a special education teacher and then encouraged by his mother, Jacqueline. Even though he is unable to use his fingers functionally, he uses his hands for this form of artistic expression. His fingerprints on the reverse side of his paintings are his signature.

Dancing

Christophe's paintings are exhibited throughout France, Italy, Japan, and the USA.

Richard Wawro was born in 1952 in Tayport, Scotland with cataracts in both eyes. Within a few months of birth, he had a series of needling operations to allow light to penetrate to the retina; he has been short sighted since birth and is legally blind.

His works have received many awards, including first prize in the American National Exhibit by Blind Artists (Philadelphia). Collectors of his works include Margaret Thatcher, the Pope, and art enthusiasts throughout Europe and the United States.

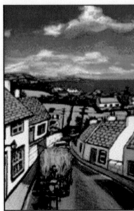

The Island Of S

Contact

Laurence A. Becker, Ph.D., Executive Director
Creative Learning Environments
507 Park Boulevard
Austin, Texas 78751-4312
USA
ph: (512) 454-4489
email: rbecker64@aol.com

Contact

www.wawro.net
Laurence A. Becker, Ph.D., Executive Director
Creative Learning Environments
507 Park Boulevard
Austin, Texas 78751-4312
USA
ph: (512) 454-4489
email: rbecker64@aol.com

Dena Gitlitz

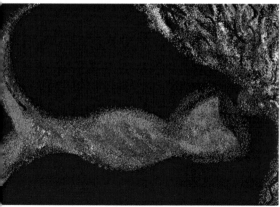

Mermaid

Dena Gitlitz is an artist, writer, jewelry designer, and speaker. Processing language is visual for her; therefore, art has been a tool for expression and communication. The "Life Under Water" series expresses many of the emotions and experiences she has had as a woman living with autism.

Dena is on the Board of the A.S.A. of the Palm Beaches and on the Board of Advisors of MAAP Services. She speaks nationally on autism/Asperger's issues.

She is currently working on her autobiography, tentatively entitled *Life Under Water*. Search www.AutismToday.com for a sampling of Dena's articles.

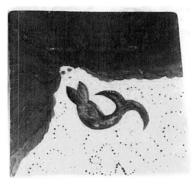

Moon In Pisces

Contact

P.O. Box 1011
Jupiter, Florida 33468
USA
email: Aspergers101@aol.com

Dominic Killiany

Flower Vase (Edouard Manet)

Dominic Michael Killiany is a six-and-a-half-year-old boy with a diagnosis of Pervasive Developmental Disorder/autism. Although he does not speak in sentences, he is capable of communicating in word groupings. He delights in pictures and the written word and is prolific in both drawing and writing.

He was reading at a second grade level prior to entering kindergarten in September 2003. The Sam Placentino Elementary School in Holliston, Massachusetts has created a special education program custom-designed for him.

Dominic's strength is his beautiful artistry combined with his peaceful, angelic demeanor; he created these works when he was four and five years old.

Contact

Susan C. Killiany (mother)
email: susan.lespritdesfleurs@verizon.net

Donna Williams

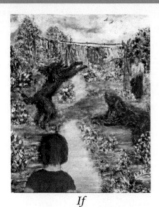

If

Donna Williams was born in 1963 and grew up in Australia. In her twenties, she was diagnosed as autistic. Her autobiography, *Nobody Nowhere*, became an international bestseller, as well as two sequels, *Somebody Somewhere*, and *Like Color To The Blind*. As an international public speaker in the field of autism, she went on to write three other books:

- *Autism: An Inside-Out Approach;*
- *Autism and Sensing: The Unlost Instinct;*
- *Exposure Anxiety; The Invisible Cage*

In addition to doing crucial work as an international speaker and advocate for individuals with neuro-developmental challenges, Donna serves as a consultant to various educational and service organizations. She is an accomplished sculptor, painter, and

singer/songwriter and this is where her spirit really seems to take wing. She and Chris Samuel married in England in December 2000 and are currently living happily ever after in the land down under.

You can ask Donna a question directly or read some of her articles through the Resident Experts section of www.AutismToday.com.

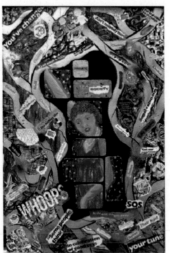

Private Society

Contact

www.donnawilliams.net
email: Donna@donnawilliams.net

Jonathan Sicoli

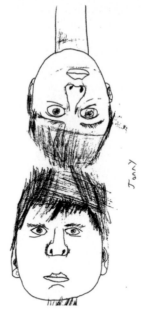

Heads

Jonathan Sicoli was born in November 1990 in Edmonton, Alberta. At the age of two and a half, Jonathan was diagnosed with PDD and, eventually, High Functioning Autism.

Karen Simmons, Jonathan's mother, wrote a book called *Little Rainman: Autism through The Eyes Of A Child* to help his peers, teachers, and family understand Jonathan's uniqueness.

Jonathan has a pleasant nature, loves the computer, plays football, and wants to be a famous inventor someday.

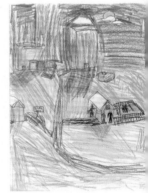

The Giver

Contact

674 Estate Drive
Sherwood Park, Alberta T8B 1M4
Canada
ph: (780) 417-0220
email: Jon@AutismToday.com

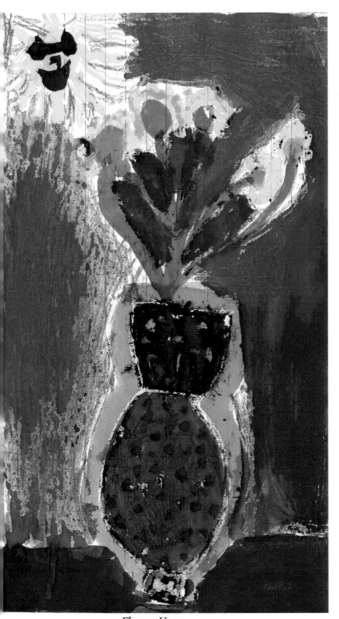

Flower Vase

Emily Estelle Carter was born July 7, 1995 in Atlanta, Georgia. She has a diagnosis of Asperger Syndrome and ADHD.

Emily is very artistically inclined and uses art heavily as a form of communication. She loves music and art, especially painting in watercolor. She uses bold coloring in her work and will sometimes paint for an eight-hour time period. When she was six years old, Emily created the painting called *"Umbrella & Rain"* which she made in school. She produced the picture *"Flower Vase"* using tempera paints on elementary lined writing paper when she was seven years old.

Emily began taking art lessons this year at a local studio, and loves to try different forms of media and texture. (One of her latest experiments in texture mixing parmesan cheese into her paint.) Her sense of perception at her young age is truly striking!

Emily is currently transitioning from a third grade self-contained learning disabled classroom into a regular education class, and is doing quite well.

Contact

Dennis & Tracy Carter
ph: (770) 253-3980
email: GaMom3@charter.net

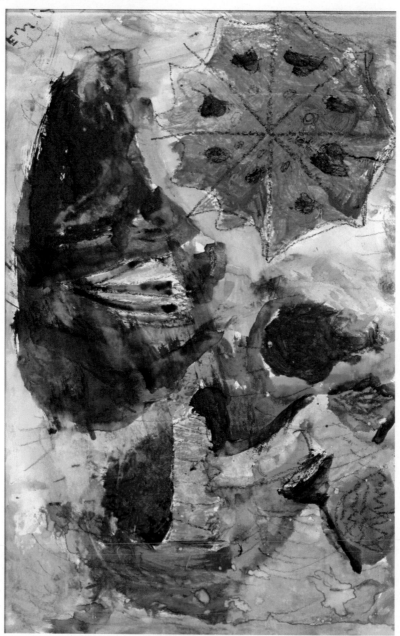

Umbrella and Rain

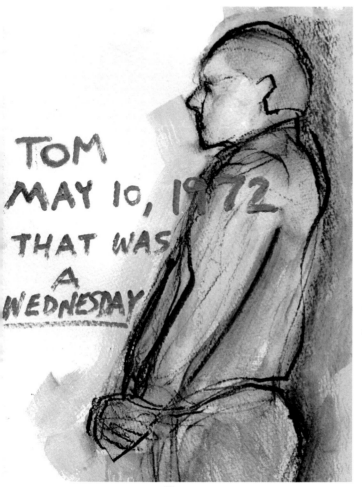

Tom

George Widener has dedicated himself to art and to his creative growth. He has won a number of scholarships that have allowed him to study drawing at the University of Tennessee at Knoxville and to travel. He devotes himself to a variety of approaches in his artwork and feels that, although he has come a long way from his simple self-taught beginnings, he has only just begun to get a "feel" of art.

George was born in 1962 with Aspergers Syndrome. He spent the early part of his childhood in the lively, "Over The Rhine" inner-city of Cincinnati, and his late childhood in Nashville.

Events and people in his life have led George to travel widely, and to consider cultural influence on the subconscious. His artwork is flavored by his natural abilities as a strong draughtsman. He has won awards in open competitions and his work has been displayed in several museums. He welcomes commission requests and opportunities to exhibit his ever-evolving work.

Contact

http://members.tripod.com/widenerart/default.html
email: widenerart@hotmail.com

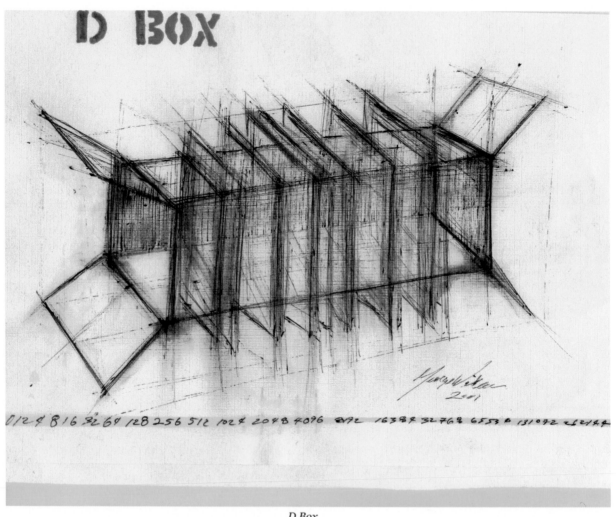

D Box

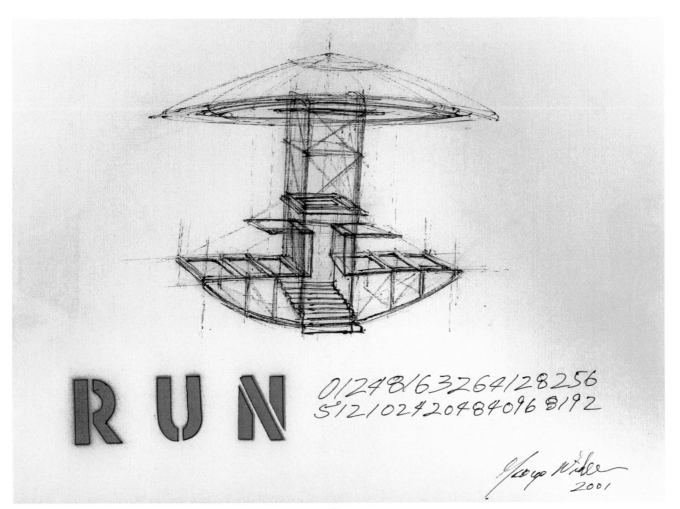

RUN

0124816326412825651210242048409681 92

Run

Jessica Davis

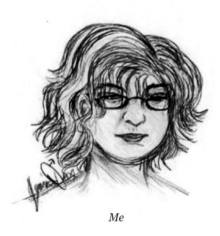

Me

Sleepy Dog

Jessica Davis is a 20-year-old with high functioning autism and PDD-NOS. As a baby and toddler, she acted as if she were deaf and ran laps in the house for several hours a day. She was largely non-verbal until she began attending special needs programs when she was two and a half. She spontaneously showed great speech improvement around the age of five.

She is currently attending college. Her interests include reading, writing, acting, history, and, most importantly, drawing.

Jessica has given presentations to the United Cerebral Palsy organization, as well as at the National Autism Society of America's 2002 Conference in Indianapolis.

Jessica's identical twin, Jocelyn, is diagnosis free and supports her sister from outside the spectrum.

Contact

www.papirini.us/index.html
P.O. Box 1064
Rome, New York 13442-1064
USA
ph: (313) 336-6558
email: halfmooncooky904@hotmail.com
 vadsha@aol.com

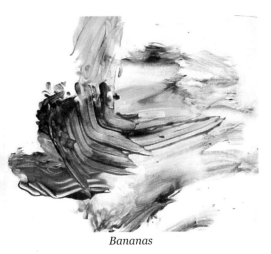

Bananas

- Harmony Arts Festival (West Vancouver) _ 2001
- Bel Art Gallery (Edgemont Village) _ February 2002
- Park-Gate Community Center _ 2002
- West Vancouver Memorial Library _ July 2003
- North Vancouver Municipal Hall exhibition / North Shore Community Arts Council _ May 2003

Elizabeth continues to look for exhibition opportunities and for collectors who can help her continue to pursue this vital form of self-expression.

Elizabeth D. was born on June 1, 1994 and was diagnosed with autism in 1998. In March, 2002 Elizabeth and her mother, Krystel, attended an intensive week in the Son-Rise Program at the Autism Treatment Center of America. Prior to the Son-Rise Program, Elizabeth was primarily non-verbal.. Since then, her vocabulary has increased remarkably; with a little prompting, she can count to 100, and she is beginning to string two words together rather than use only single words.

Since Krystel also has a passion for art, Elizabeth has attended many art exhibitions and has been fortunate enough to visit art museums in Germany and Poland. When her mother painted murals in an antique shop, Elizabeth would watch from her play pen. She absorbed her mother's devotion to colour and uses it to express her emotions. Elizabeth's work has been well received by the local art community which has been a godsend in terms of her emotional growth.

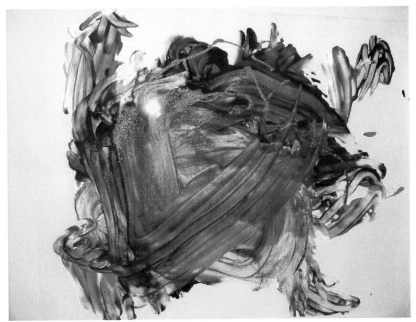

Help Me

Contact

www3.telus.net/eliz/eliz
Krystel D. (mother)
email: krysteldurian@yahoo.com

Joel Anderson

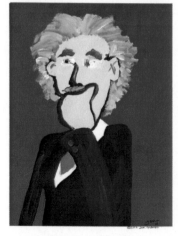

Thinking Einstein

Joel Anderson has been drawing since the age of five and always has a pencil in hand. His own unique style and imagination is inspired by the lives and works of DaVinci, Picasso, VanGogh, and Ray Blavatt. He enjoys acrylic and watercolor painting, as well as computer art which he produces with a freehand mouse technique. Joel is starting to explore computer and cartoon animation and is applying his talents to a children's book featuring a pirate named William.

He illustrated a book published by Dr. Cynthia Norall entitled *Families and Transitions: A Different Dream.* He also has illustrated several yet-to-be-published books written by other local professionals for families with special needs.

Joel has been the featured artist in several shows, including the Autism Tree Project. His "on-the-spot" portrait of Doug Flutie during the opening ceremonies and 3 additional artwork contributions raised $1,000 for the project. He has won several awards in San Diego County and has been featured in several local newspapers and on local television.

Joel is excited about a mother-son duo speaking engagement for the Autism Tree Project in 2004 when he will address parents of preschoolers with special needs. Joel's older brother, Jared, has a diagnosis of autism and FG Syndrome.

Joel loves it when his art makes people smile. His family established a business that will make it easier for him to sell his originals as well as the card sets, magnets and prints reproduced from his work.

Contact

Joel's Vision Arts
1318 Friends Way
Fallbrook, California 92028
USA
ph: (760) 731-0913

Mona Lisa

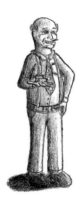

Jonathon Kane was born on October 24, 1983 and diagnosed with Aspergers Syndrome when he was very young. The diagnosis was difficult to make, however, because he was diagnosed with several other psychiatric disorders at the same time... As a result of a series of extremely painful events involving school bullying starting in 1995 and continuing through to 2001, Jonathon developed severe Obsessive-Compulsive Disorder.

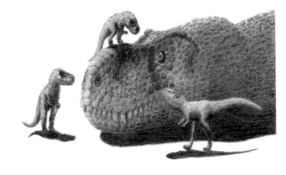

MR.TOOTHPICKS:
It's Mr. Toothpicks, the toothpick salesman from the DeRaptor forum! His appearance is based loosely on Mr. Canik, a math teacher I had in 7th and 8th grade. Mr. Toothpicks gave me his permission to draw this.

MAMA REX:
Even the most ferocious dinosaurs could be loving parents. Various findings of families of dinosaurs suggest that they were very similar to birds in the way they took care of their offspring. The fuzzy coating on the babies is based on the discovery of various dinosaurs whose skin shows the impressions of primitive feathers. These feather impressions have been found on many different branches of a group of carnivorous dinosaurs called coelurosaurs.... Tyrannosaurus is a coelurosaur, so it likely had feathers at some point in its life, although once it was full-grown, it was probably large enough that it didn't need insulation.

ART is the exclusive domain where Jonathon finds comfort and establishes self-acceptance. "Aspergers gives me an extremely powerful imagination, but it also makes me very sensitive to stress." says Jonathon. "When faced with this type of stress, people with Asperger's Syndrome often develop Obsessive-Compulsive Disorder, and I was no exception to this. I had always been obsessive when I was trying to get a drawing exactly right, but now my obsessive tendency has spread to things I wish I didn't care about at all... every day my OCD consumes about seven hours of my life."

ARCHAEOPTERYX:
Archaeopteryx lithographica is the earliest known bird, living 150 million years ago in what's now Germany. There's an implied pun in this picture, if you can figure it out. The original pale blue color of the sky was lost when I scanned it, and no amount of tinkering can get it back.

Contact

www.raptoric.com/~aggie
www.side7.com/art/jonakane
email aggie@raptoric.com

I Lost My Head

Faith Butterfield is a seven-year-old girl who has autism. Her younger sister, Grace, has been diagnosed with Aspergers Syndrome but that has not stopped her from obtaining her first ever dramatic role in a Carousel Kids non-profit theatre production!

Faith started drawing when she was two years old and, to this day, draws at least two hours each day. She has no formal training, as yet. Her major interests are Egyptology, astronomy, and zoology.

Tammy Camou-Butterfield is a tireless advocate for inclusive programming and open doors for people on the spectrum. Her role as an advocate has become even more crucial to the girls' future success since the Butterfields lost their home and all their earthly possessions to the California wildfire rampage in the autumn of 2003. Because the family can claim no permanent residence until they either build or buy a new home, Tammy has been struggling to secure educational and other supports that Faith and Grace need.

When we spoke with Tammy in January 2004, she was amazingly light-hearted despite the fact that her girls are having significant emotional difficulties with the loss of so much that is familiar and comforting to them. All funds received from the sale of Faith's art are designated for a trust fund that has been set up for the two sisters. We wish them the very best of luck!

Contact

Tammy Camou-Butterfield (mother)
3727 N Equation Road #68
Pomona, California 91767 USA
ph: (909) 596-9554
email: saving_faith@hotmail.com

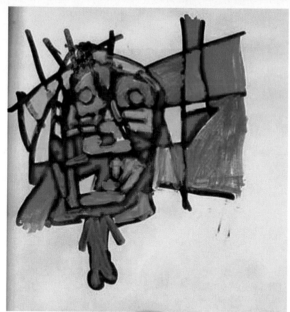

The Complexity Of Emotions

Gene Fernando, born on August 10, 1992, was diagnosed with autism when he was three and a half years old. He could not speak until he was five, nor could he hold a pencil usefully until he was seven years old. It was then that a new world of expression opened up for him.

Gene loves to write and draw. His mother hopes that one day she will find an art instructor who will help him reach his full artistic potential. Gene's other interests include music as well as physical activities such as climbing, jumping, swimming, and shooting basketball.

Contact

www.geocities.com/crystal_fernando/GeneArt.html
Crystal Fernando (mother)
San Marcos, California
USA
email: crystal_fernando@yahoo.com

Some of his creations include a series of stories and films which he makes on the family camcorder. He pays attention to many details: the opening credits, identifying the writer, and adding his own logo and theme song.

For Michael, every day is a new adventure. He has big dreams of going to Hollywood and directing his own feature films. Every morning he asks, "Are we going to Universal today?" Someday his family hopes to answer, "Yes Michael! Let's go!"

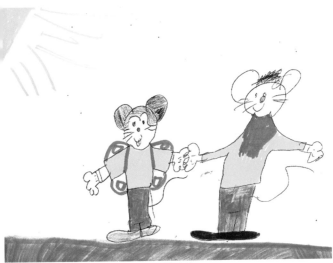

Friendly Mice

Michael Igafo-Te'o is a loving nine-year-old boy who lives in Michigan with his parents, his older brother, and his younger sister. He was diagnosed with autism at the age of three. His mother serves as Webmaster and Director of Information Technology & Information Systems for Bridges4Kids, a non-profit organization providing a comprehensive system of information and referral for parents of children from birth through transition to adult life. (www.bridges4kids.org)

Michael showed an interest in reading and art very early in life. When he was only three years old, Michael was already reading newspapers. By the age of five, he was drawing and writing his own stories. His artwork is his favorite way of communicating with the world around him.

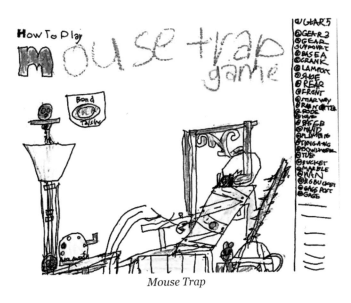

Mouse Trap

Contact

313 Randolph
Jackson, Michigan
USA
ph: (517) 796-2071
email: igafoteo@ameritech.net

Joshua Samuels

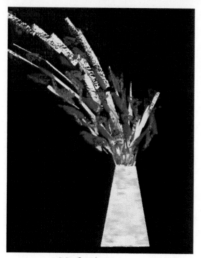

Mother's Day

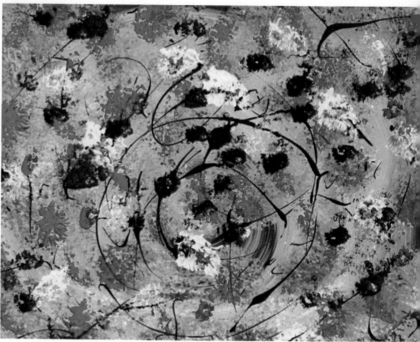

Acrylic Artwork

Joshua Wayne Samuels was born December 25, 1984. He is challenged by autism and has difficulty with expressive language. Regardless, he has an expressive voice on canvas!

Joshua's freedom to paint in a variety of ways allows him endless opportunities to create with enthusiasm and become the paint-filled urn. When he is deep in his art, his usually expressionless face adopts a joyful glow; when he lifts his brush to communicate, the corners of his mouth uplift in a smile. This is Joshua's way of speaking. He can laugh and sing with his acrylic paints and select his words from a spectrum of rainbow colors.

Joshua's mother, Donna Samuels, is one of the co-creators of the Autism Arts website.

Contact

www.kyol.net/~samuels
Donna Samuels (mother)
189 East Shannon Lane
Mt. Washington, Kentucky
USA
ph: (502) 538-6195
email: samuels@bullitt.net

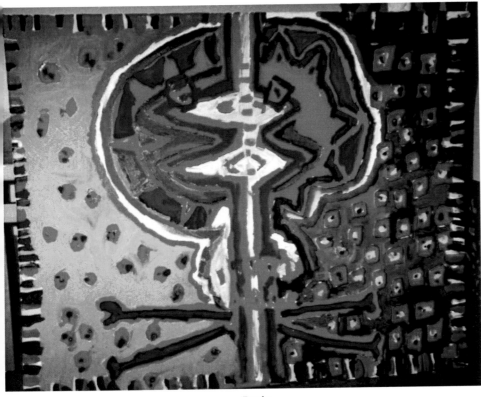

Brain

I am Remco Rink and I'm 20 years old. When I was a little boy, I always drew pictures in all kind of colours. When I was old enough to go to school, I had a very hard time accepting myself. Since 2001, I have worked at a studio with other handicapped individuals. I am the only person with autism there. Most of the time I am painting. However, I also draw pictures, write poems, and make sculptures.

My wish for the future is to become a famous artist with my own studio and find a very nice girlfriend.

Contact

Holtwiklanden 258
Enschede, Overijssel
Netherlands
ph: 31 053 477-6390
email: jan-irma@home.nl

The Maze

Kyle Raymond Fourroux

Meadow

Kyle Raymond Fourroux is 12 years old. He lives in Kenner, Louisiana with his parents, Bridget and George, as well as his sister, Brittney. Kyle was diagnosed with autism at the age of three.

He is in the fifth grade at John Clancy Elementary School, where he is in an art class for talented students. He had several pieces of his artwork displayed in an art fair this year. Kyle prefers to draw in pencil; however, he is beginning to explore watercolor, pastel, and charcoal during his school day. One of Kyle's greatest talents is his ability to memorize a visual image and draw almost any picture of it in just a few minutes.

Contact

2014 Toledano Street
Kenner, Louisiana 70062
USA
ph: (504) 467-7787
email: smroux@aol.com

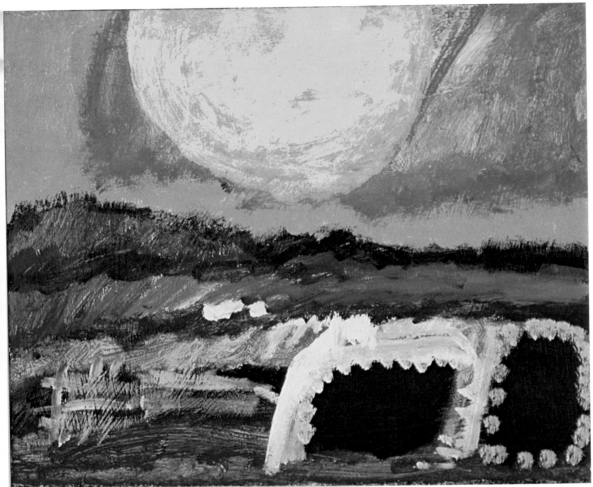

The Ocean's Deep End

My name is Noah Erenberg. I create art because it makes me feel wonderful. I like to paint outside and look at different trees, the ocean, and the surfers. My artist friends inspire me to paint. They come over and make me happy about my art. With every good painting I make, I improve as an artist. I like to go to art shows and sell my paintings.

I like abstract paintings because I like bright colors and crazy shapes. This type of art reminds me of hip hop music. It seems as if the shapes come out of my head. Abstract means "from my head."

Noah Erenberg

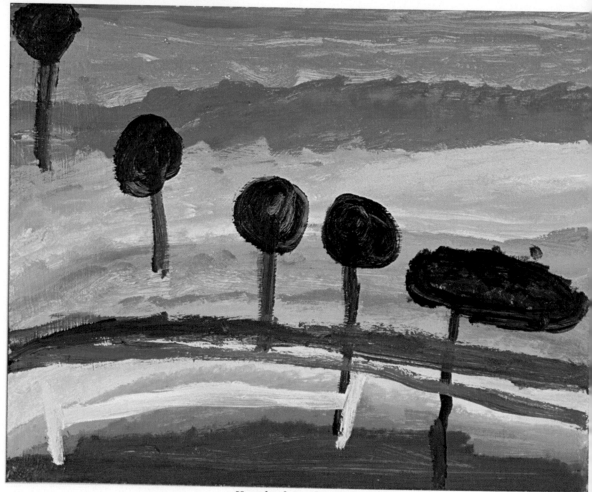

Horseland, Landy, Land

Contact

http://elenamarysiff.com/noah/
947 25th Street
Santa Monica, California 90403
USA
ph: (310) 453-4258
email: esiff@att.net

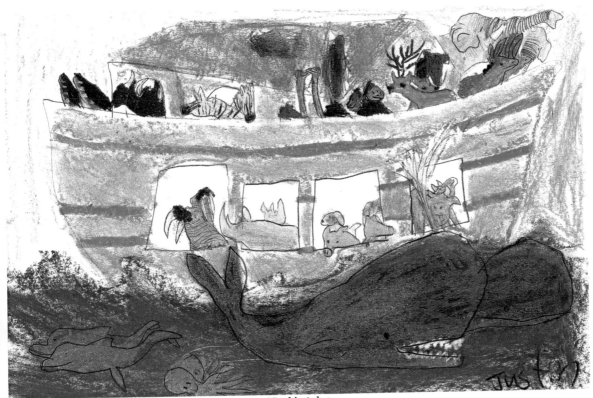

Noah's Ark #1

Justin Canha was diagnosed with autism/PDD at the age of three. He is 14 years old and lives in Montclair, NJ, where he participates in a fully inclusive environment at Renaissance Middle School. While his verbal communication skills were heavily compromised as a child, Justin would draw different scenarios to express what was happening to him. The drawings served as a bridge to verbal expression and his parents soon discovered that he had been blessed with an innate artistic talent.

Since age 5, Justin has had a passion for drawing animals and cartoon characters. At age 9, Justin won "Best in Show" for Cartooning, competing with students from Kindergarten through High School in Palm Beach County, Florida. Since then, he has expanded his repertoire to encompass still-life work, portraits, florals, landscapes and buildings in a variety of media including watercolors, pastels, charcoal, and oils. Justin has produced a sizeable volume of commission work, which hangs in private homes around the world, including Brazil, Canada, Germany, France, and Fiji. Although he accepts commissions for buildings and human portraits, his favorite is pet portraits.

Self Portrait

Justin Canha

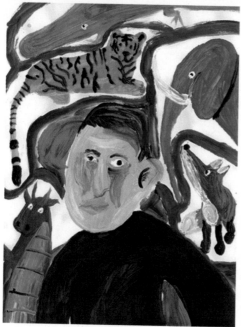

Animals And Me

Justin also has taught himself how to create computer animations, some having up to 200 frames per cartoon. If you were to ask Justin what he wants to be as an adult, he would confidently answer, "An illustrator and a computer animator." It is his parents' fervent prayer that he will achieve his dream.

You can read an article on Justin in Autism Today's archives at:
www.autismtoday.com/creative/justin.htm

Contact

www.justinart.com
email: mrsmtcanha@yahoo.com

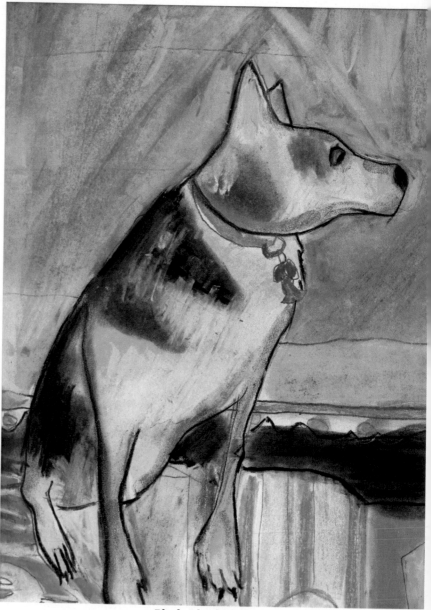

Rhode Island Doggie

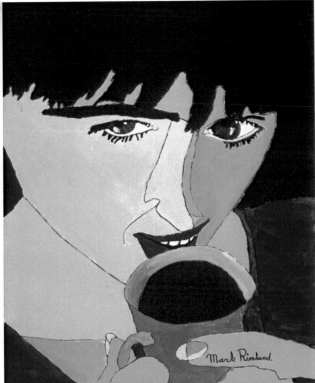

Lady Drinking Coffee

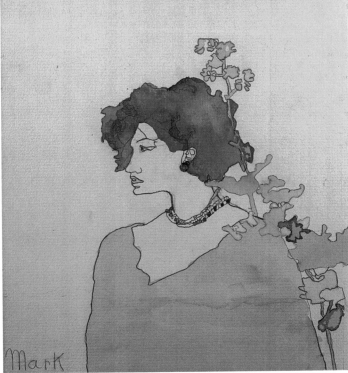

Red Haired Lady

Mark Rimland is an accomplished artist with both a national and international reputation. He has appeared on American television, as well as the Australian edition of "60 Minutes" and Japanese NTV. Mark illustrated *The Secret Night World of Cats,* a children's book written by his sister, Helen Landalf, which won a parenting award in 1998. Mark has shown his art in several group exhibitions and one-man shows.

His art is reproduced on several greeting cards and prints which are sold online at https://secure.completeofficeservices.com/smsc/shopnow.html

Contact

Sophie's Gallery
109 Rea Avenue
EI Cajon, California 92020
USA
ph: (619) 593-2205

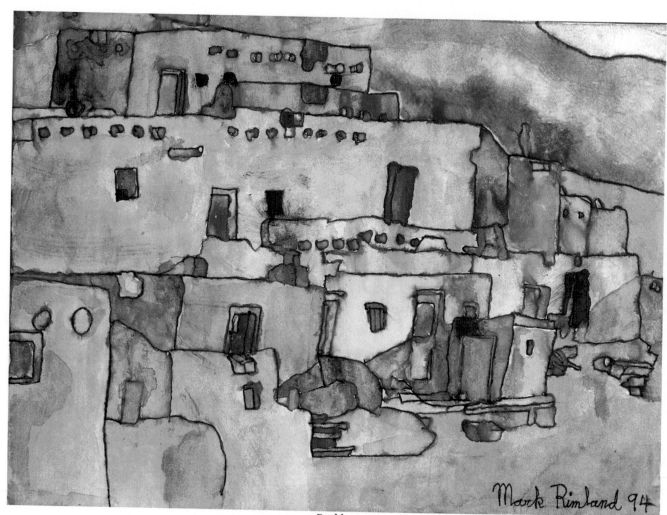

Pueblo

Mark Rimland 94

Medieval Contemplations

Joseph Camacho was born January 23rd, 1974 *(Happy 30th Birthday, Joseph!!)* and was identified as being on the spectrum with probable PDD / Aspergers Syndrome only in 2002.

"My interests include watching movies that star Humphrey Bogart, in addition to films from the comedy genre. I also enjoy watching wrestling, playing games at the arcade, taking care of my Siberian Husky named Crystal. I used to go on all the rides at the Great Adventure Theme Park but now we live farther away, it costs much more money, and it's hard for me to find people who still enjoy the rides. *[Joseph's mother Delphine laughs, "He's absolutely fearless with those rides!"]* One of my pieces hangs on the wall of the YAI in Bayside, New York." (www.yai.org)

These paintings were used as illustrations for a series of stories that Joseph has written. He is passionate about bringing them to print for a larger audience but has yet to secure the resources of a good editor to help achieve this dream. His family invites your support and encouragement in this regard!

Contact

8521 168th Street
Jamaica, New York 11432-2623
USA
ph: (718) 526-6008

Off To Battle

Kyle Leahy Walsh

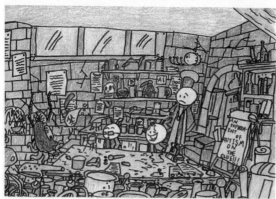

Untitled

My name is Kyle Leahy Walsh. I'm 12 years old. I have red hair. I'm kind and friendly, but I'm a little bit shy. My family is great. They live in New York, Florida, Ireland, and England. I love to go visiting them, especially when we get to fly in an airplane.

I had a big adventure in Hong Kong and China last year. Mom, Dad, and I went to meet my new sister. She's cute and fun and she's six years old. Sometimes she's a little rude. Her name is Kiera Therese Pei Pei. Most days, I like having a sister.

I have three dogs. They're named Callahan, Shanahan, and Sweeney. I'm lucky to have lots of friends. Some of them have autism, some have other challenges, and others do not have disabilities. We take karate classes together.

School makes me nervous. I like swimming, bowling, and going to the movies.

Most of all, I love drawing. Drawing makes me feel good. I really like drawing cartoon characters. Sometimes I use colors, but I enjoy drawing with black ink the most. Maybe one day I can be a cartoonist like Charles Shultz, who created "Peanuts," or Jim Davis, who created "Garfield."

Contact

c/o Autism Today
2016 Sherwood Drive Suite 3
Sherwood Park, Alberta T8A 3X3
Canada
Ph: (780) 417-2874
Fx: (780) 452-1098

Lloyd Allanson

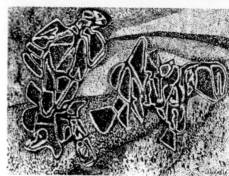

Someone Met A Cow

Lloyd Allanson is eight years old. He was born in Princeton, USA and currently lives in Edinburgh with his mother and sister. His grandmother is a professional artist working in France.

These paintings were made when Lloyd was about five years of age. At the time, he was willing to comment about his thinking processes as he created. At six, Lloyd experienced severe regression and was diagnosed with autism. At seven, he was reluctant to hold a pen or to talk about his inner view of the world around him. After nearly two years of intensive home education and biomedical interventions (DAN!), Lloyd is now using his pen again and is more engaged. He is, however, still not drawing.

In "Someone Met A Cow," the figures are not in harmony—the cow seems harmless and placid as are most cows; but the someone seems to be in such deep distress that he is screaming to the sky. "Map" embodies Lloyd's frequent complaint of being lost. When he was doing this drawing, he was reciting "we turn left and then we turn right," as if he was trying to map out some personal space for his own reassurance. We present this canvas as a negative of the original drawing.

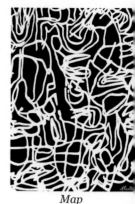

Map

Contact

Lorene Amet, D. Phil
6 Greenbank Avenue
Edinburgh, Scotland EH10 5RD
ph: 01 31 447 7543
email: greenbank.edi@btopenworld.com

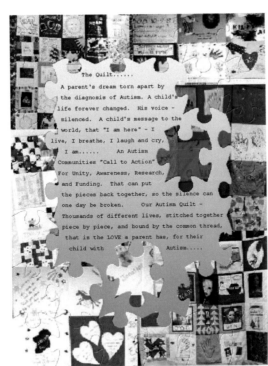

The Quilt

A parent's dream torn apart by the diagnosis of autism.
A child's life forever changed.
His voice - silenced.
A child's message to the world, that
 I am here,
 I live, I breathe,
 I laugh and cry,
 I am...
An autism community's "Call to Action"
for unity, awareness,
research, and funding.
That will put the pieces back together -
so the silence will one day be broken.
Our autism quilt -
thousands of different lives, all stitched together
piece by piece
And bound by a common thread, that is...
the love
that a parent has for their child with autism..

Todd and Michelle Guppy live in Cypress, Texas. They are the proud parents of Matthew and Brandon, who is a 10-year-old with autism.

Todd designed this graphic and Michelle wrote the poem "The Quilt" after they were inspired by the tenderness and tenacity that was stitched into the Call to Action Quilt for Autism Awareness. Todd manipulated digital images from the quilt panels to create the puzzle pieces.

The actual Call to Action Quilt (www.autismconference.org/quilt. htm) was stitched together by Nancy LeGendre (NLeGendre@aol. com) and crew from fabric squares submitted by individuals with autism and their families from all around the world.

Contact

http://health.groups.yahoo.com/group/Texas-Autism-Advocacy
http://health.groups.yahoo.com/group/autism-awareness-action
http://health.groups.yahoo.com/group/SeekingJoyinDisability

16210 Cypress Trace
Cypress Texas 77429
USA
email: tguppy@LGC.com
 michellemguppy@yahoo.com

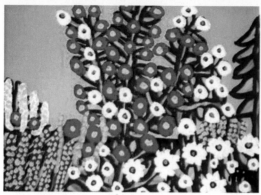

Flowers 1

Ron Chertkow was born in Vancouver in 1956, and has lived in Kamloops, British Columbia since the age of three. He has made the most of his life as a person with autism—he enjoys living up to his potential as a useful member of society and he enjoys exploring his many interests.

Ron works in the schools as a volunteer librarian. He also is involved in volunteer work at the Kamloops Museum because of his great interest in local history. He is very fond of music, especially country, folk, and rock.

Painting has opened up a new world for Ron. He has a naive and innocent style that layers vivid shapes, colours, and forms upon the canvas.

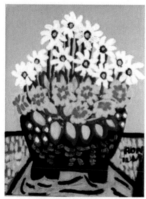

Summer Days

Self Beauty

Sara Moodie is a 27-year-old woman with Asperger's Syndrome who lives in Ontario, Canada. She has been drawing ever since she could hold a pencil. She also works on cartoon characters, freelance advertising, and architectural drawing. She also enjoys designing and working with stained glass.

Sarah supports herself by working in IT, repairing computers. Her interests include computers, musical theatre, writing, language, and forensic sciences.

Contact

email: jeanron2@shaw.ca

Contact

email: saratech@sympatico.ca

Rick Morrison

Phillip McMurray

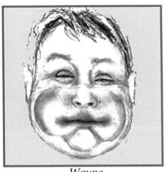

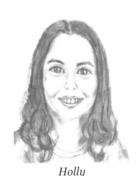

Holly

Wayne

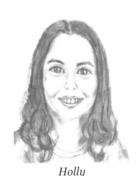

Tornado

Rick Morrison was born on February 23, 1984 and was diagnosed with autism/Aspergers around the age of ten. He lives in Michigan with his mother, father, and two younger sisters.

Rick started to draw when he five years old and particularly enjoys drawing buildings and famous people. He also enjoys taking photographs with his Polaroid camera. His artwork was showcased in Australia at the Inaugural World Autism Congress in November 2002.

Rick was interviewed on camera in July 2003 for a documentary project called "Law Enforcement & Autism" which was produced by Dennis Debbaudt and Dave Legacy. This program brought autism awareness to police, fire fighters, ambulance personnel, hospital professionals, and other first responder emergency personnel. (www.autismriskmanagement.com)

Phillip McMurray was born on February 12th 1995. He and his twin brother Ryan are on the autistic spectrum and were diagnosed with PDD / Aspergers Syndrome just prior to their second birthday. They live with their mother, Sandra, in Michigan. Sandra co-founded Autism Arts and is working hard to establish new physical facilities for the McMurray A.R.T.S. Center.

Phillip was six years old when he created "Tornado" for the UC Davis M.I.N.D. Institute's Art Exhibition. "Tornado" is now on permanent display in the institute's new center, which opened in April 2003. It is also included in *ART OF THE MIND: The Art Collection of the UC Davis M.I.N.D Institute*, available for purchase at www.ucdmc.ucdavis.edu/mindinstitute/html/events/books.html.

Contact

McMurray A.R.T.S. Center
P.O. Box 423
Eastpointe, Michigan 48021
USA
ph: (586) 777-7533
email: info@autismarts.com

Contact

McMurray A.R.T.S. Center
P.O. Box 423
Eastpointe, Michigan 48021
USA
ph: (586) 777-7533
email: info@autismarts.com

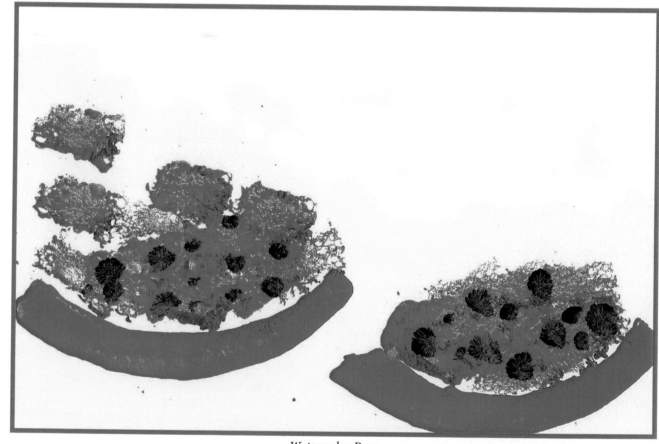

Watermelon Days

Ryan McMurray was born on February 12, 1995, along with his twin brother, Phillip. Both boys were diagnosed with an ASD just prior to their second birthday; Ryan has an additional diagnosis of PDD-NOS. They live in Michigan with their mother, Sandra, who co-founded Autism Arts.

Ryan created "Watermelon Days" in his special education classroom when he was five-and-a-half years old. He loves to play video games on his PlayStation, draw buildings, and create towers from almost anything he can find in the house.

Contact

McMurray A.R.T.S. Center
P.O. Box 423
Eastpointe, Michigan 48021
USA
ph: (586) 777-7533
email: info@autismarts.com

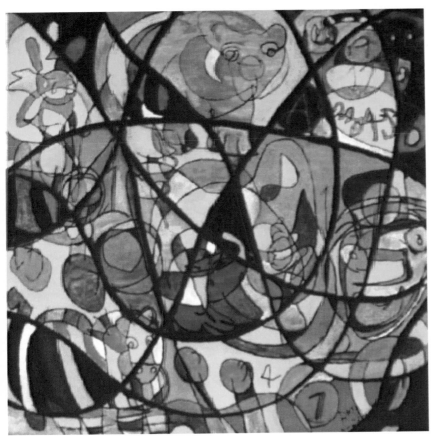

US#2

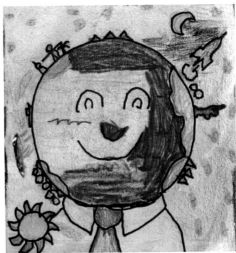

It's My World

Hello, my name is Perapoon Rhys Owen Wynne and I live with my daddy in Bangkok, Thailand. I was born on September 2, 1990. I go to a Wathanamasee School in Bangkok.

On weekends, I go to a special art school to learn how to draw cartoon characters. I like my teachers very much because they are nice to me.

I like to read stories. I also enjoy writing my own stories. When I grow up I want to be a writer and an artist. I like to paint with my daddy in his studio. We have a good time together. When we sell our paintings, we give money to help children with autism here in Thailand.

Rhys Wynne

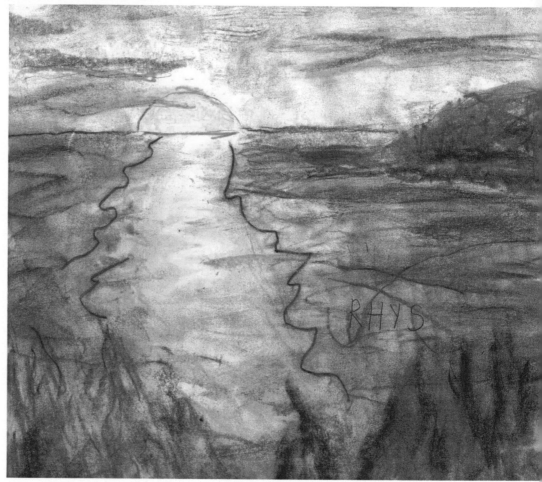

Sunrise At Bangsen

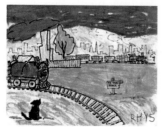

Little Puff

Contact

www.rhyscorner.aasianart.com
POB 10 Onnut Post Office
Bangkok, BK.
Thailand
ph: 662 321-3456
email: easy@ksc.th.com

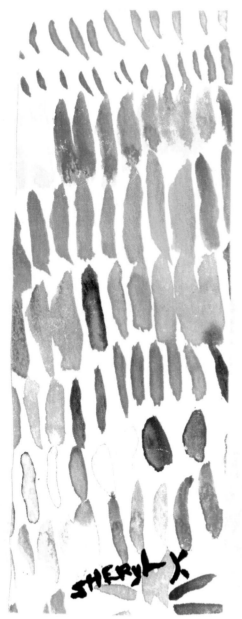

Strips And Bars

Sheryl Yeager is a 42-year-old woman with high functioning autism.

"I find it difficult to cope with the rest of the world. Having autism is a struggle, especially competing with other people in jobs, socializing, and in all areas. When people don't accept me for who I am, I feel very sad."

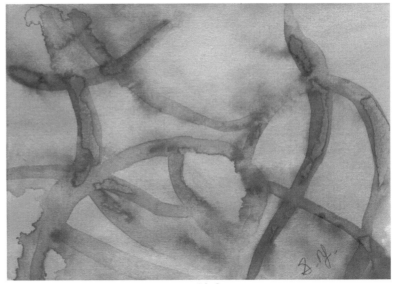

Untitled

Contact

#301Crafton Plaza
25 East Crafton Avenue
Pittsburgh, Pennsylvania 15205-2860
USA
ph: (412) 919-5995

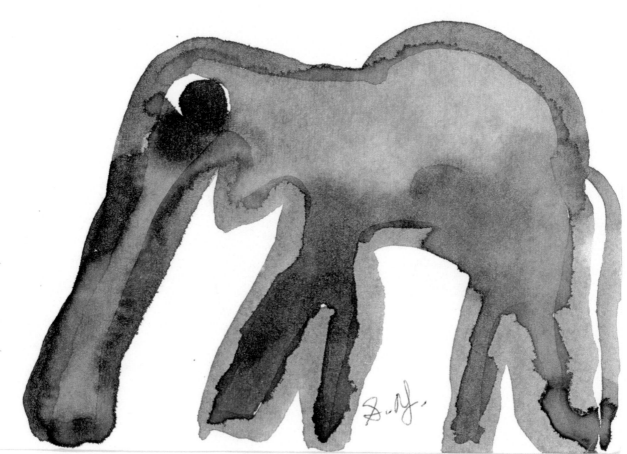

Zoo Life

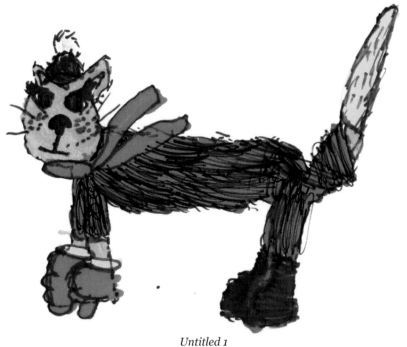

Untitled 1

Valerie Heintz is an eight year old artist with autism.

"When I grow up I want to be an art teacher. I like to climb trees and go swimming at the pool. I really like Florida because it has lots of beaches. When I go to the beach, I like to go boogie boarding and make sand castles. My favorite animals are bunnies and skunks, because they are cute. I started creating art when I was two years old. I like to paint, use markers, and make 3D cut-and-paste projects."

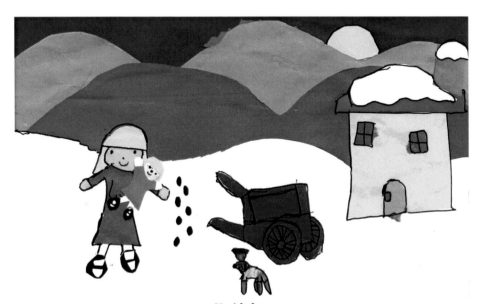

Untitled 2

Valerie Heintz

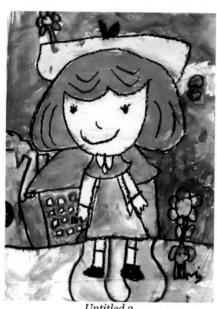

Cats

Untitled 3

Contact

Canadian Autism Resources & Events
2016 Sherwood Drive Suite 3
Sherwood Park, Alberta T8A 3X3
Canada
ph: (780) 482-1555
toll-free: 1-877-482-1555

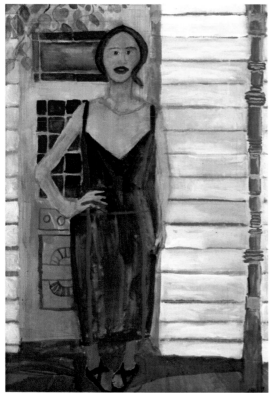

Woman In Front Of Door

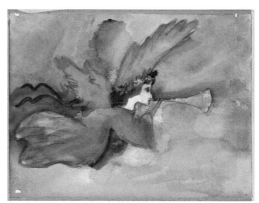

Angel

Kristina Woodruff loves to paint and has an innate sense of color. Her favorite subjects include architecture, foreign cultures, and space themes. She has shown her art in several group exhibitions and one woman shows.

Kristina's art is reproduced on cards and prints, sold online at https://secure.completeofficeservices.com/smsc/shopnow.html

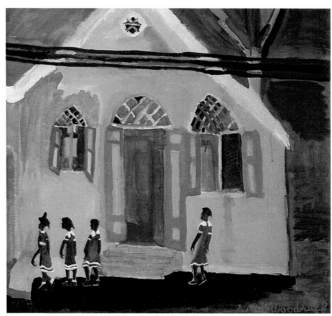

Pink Church

Kristina Woodruff

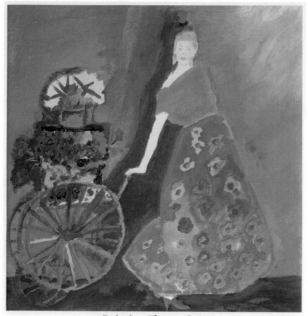

Painting Flower Cart

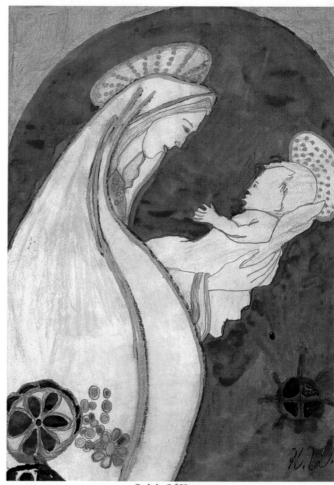

Spirit Of Xmas

Contact

Sophie's Gallery
109 Rea Avenue
EI Cajon, California 92020
USA
ph: (619) 593-2205

Kevin Carlson was born in 1978. He has loved to draw ever since he was a young child. He illustrated several books written by his older brother, Richard, including two children's books about autism. Kevin currently works at Sage, a business that employs handicapped people. Sage sells a variety of crafts and decorative items in their store and through the mail. (www.hugsfeelgood.com/sage_crafts_store.html)

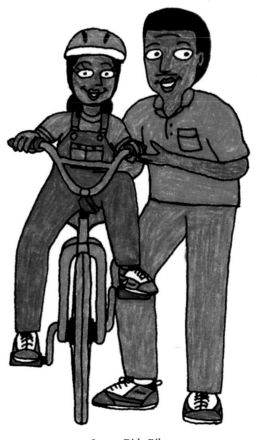

Learn Ride Bike

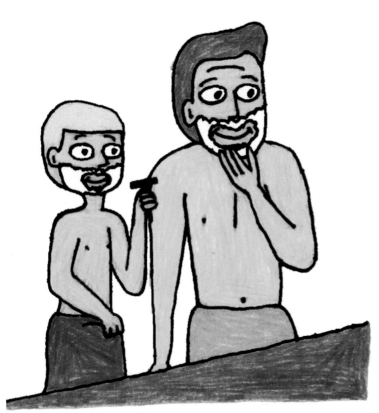

Buddies

Contact

ph: (520) 742-5364
email: kevin@hugsfeelgood.com